Patterning Techniques

A pattern is a repetition of shapes and lines that can be simple or complex depending on your preference and the space you want to fill. Even complicated patterns start out very simple with either a line or a shape.

Repeating shapes (floating)

Shapes and lines are the basic building blocks of patterns. Here are some example shapes that we can easily turn into patterns:

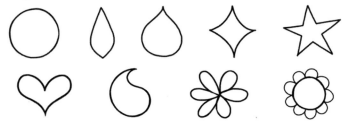

Before we turn these shapes into patterns, let's spruce them up a bit by outlining, double-stroking (going over a line more than once to make it thicker), and adding shapes to the inside and outside.

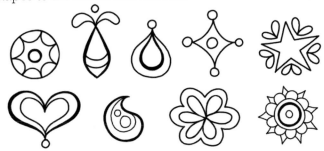

To create a pattern from these embellished shapes, all you have to do is repeat them, as shown below. You can also add small shapes in between the embellished shapes, as shown.

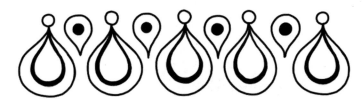

These are called "floating" patterns because they are not attached to a line (like the ones described in the next example). These floating patterns can be used to fill space anywhere and can be made big or small, short or long, to suit your needs.

Tip

If you add shapes and patterns to these coloring pages using pens or markers, make sure the ink is completely dry before you color on top of them; otherwise, the ink may smear.

Repeating shapes (attached to a line)

Start with a line, and then draw simple repeating shapes along the line. Next, embellish each shape by outlining, double-stroking, and adding shapes to the inside and outside. Check out the example below.

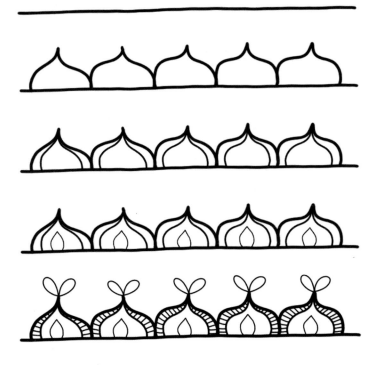

You can also draw shapes in between a pair of lines, like this:

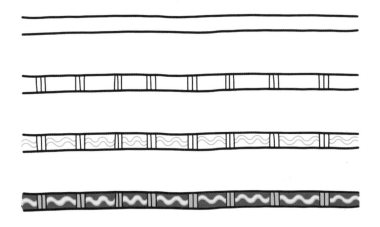

Tip

Draw your patterns in pencil first, and then go over them with black or color. Or draw them with black ink and color them afterward. Or draw them in color right from the start. Experiment with all three ways and see which works best for you!

Embellishing a decorative line

You can also create patterns by starting off with a simple decorative line, such as a loopy line or a wavy line, and then adding more details. Here are some examples of decorative lines:

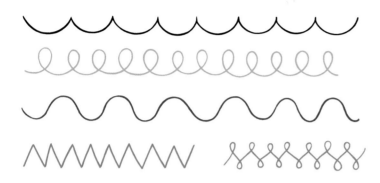

Color repetition

Patterns can also be made by repeating sets of colors. Create dynamic effects by alternating the colors of the shapes in a pattern so that the colors themselves form a pattern.

Next, embellish the line by outlining, double-stroking, and adding shapes above and below the line as shown here:

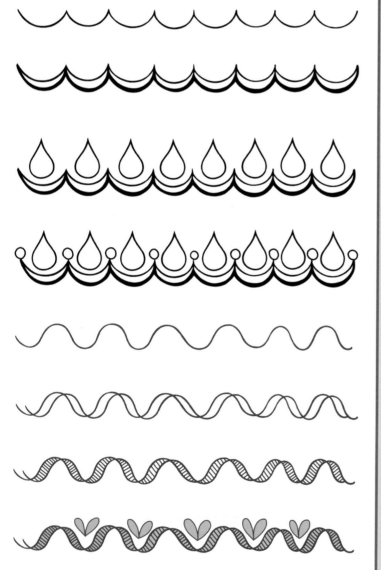

Tip

Patterns don't have to follow a straight line—they can curve, zigzag, loop, or go in any direction you want! You can draw patterns on curved lines, with the shapes following the flow of the line above or below.

These types of patterns look great when attached to the inner or outer edge of a drawing, such as the inside of a flower petal or butterfly wing.

Coloring Techniques & Media

My favorite way to color is to combine a variety of media so I can benefit from the best that each has to offer. When experimenting with new combinations of media, I strongly recommend testing first by layering the colors and media on scrap paper to find out what works and what doesn't. It's a good idea to do all your testing in a sketchbook and label the colors/brands you used for future reference.

Markers & colored pencils
Smooth out areas colored with marker by going over them with colored pencils. Start by coloring lightly, and then apply more pressure if needed.

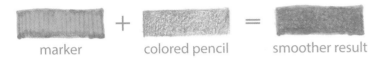

marker　　+　　colored pencil　　=　　smoother result

Test your colors on scrap paper first to make sure they match. You don't have to match the colors if you don't want to, though. See the cool effects you can achieve by layering a different color on top of the marker below.

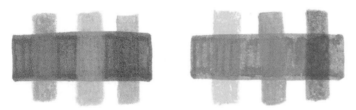

Markers (horizontal) overlapped with colored pencils (vertical).

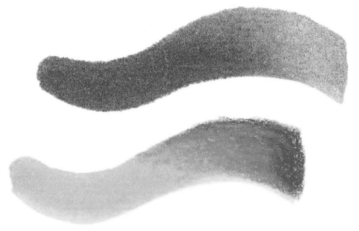

Purple marker overlapped with white and light blue colored pencils. Yellow marker overlapped with orange and red colored pencils.

Markers & gel pens
Markers and gel pens go hand in hand, because markers can fill large spaces quickly, while gel pens have fine points for adding fun details.

White gel pens are especially fun for drawing over dark colors, while glittery gel pens are great for adding sparkly accents.

Shading

Shading is a great way to add depth and sophistication to a drawing. Even layering just one color on top of another color can be enough to indicate shading. And of course, you can combine different media to create shading.

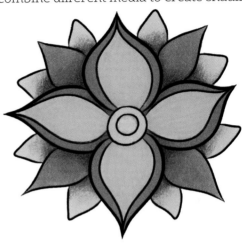

Colored with markers; shading added to the inner corners of each petal with colored pencils to create a sense of overlapping.

Colored and shaded with colored pencils.

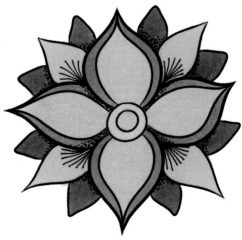

Lines and dots were added with black ink to indicate shading and then colored over with markers.

Color Theory

Check out this nifty color wheel. Each color is labeled with a P (primary), S (secondary), or T (tertiary). The **primary colors** are red, yellow, and blue. They are "primary" because they can't be created by mixing other colors. Mixing primary colors creates the **secondary colors** orange, green, and purple (violet). Mixing secondary colors creates the **tertiary colors** yellow-orange, yellow-green, blue-green, blue-purple, red-purple, and red-orange.

Working toward the center of the six large petals, you'll see three rows of lighter colors, called tints. A **tint** is a color plus white. Moving in from the tints, you'll see three rows of darker colors, called shades. A **shade** is a color plus black.

The colors on the top half of the color wheel are considered **warm** colors (red, yellow, orange), and the colors on the bottom half are called **cool** (green, blue, purple).

Colors opposite one another on the color wheel are called **complementary**, and colors that are next to each other are called **analogous**.

Look at the examples and note how each color combo affects the overall appearance and "feel" of the butterfly. For more inspiration, check out the colored examples on the following pages. Refer to the swatches at the bottom of the page to see the colors selected for each piece.

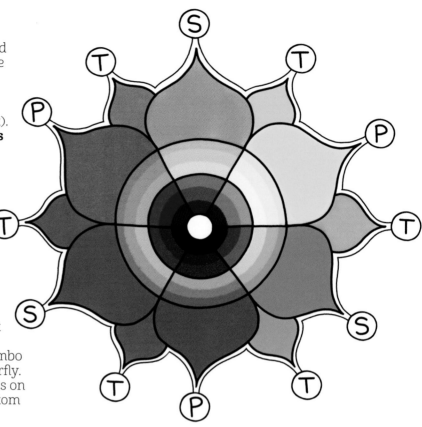

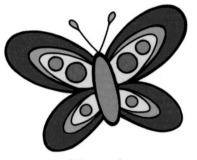

Warm colors

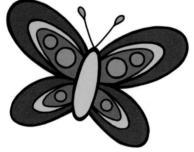

Cool colors

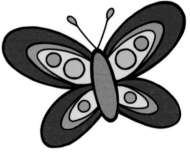

Warm colors with cool accents

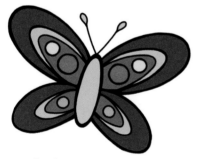

Cool colors with warm accents

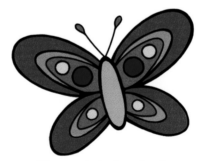

Tints and shades of red

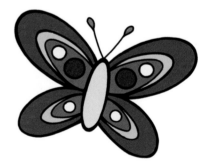

Tints and shades of blue

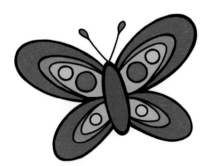

Analogous colors

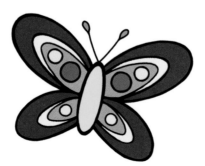

Complementary colors

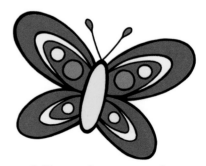

Split complementary colors

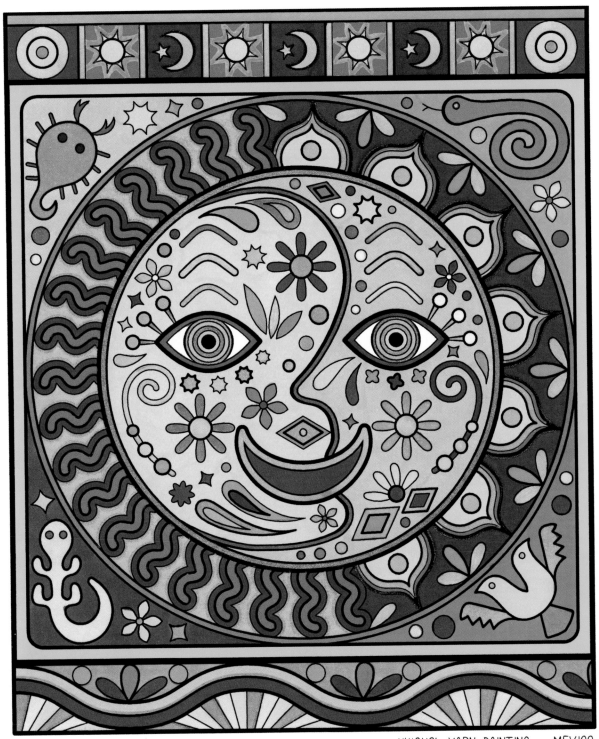

HUICHOL YARN PAINTING - MEXICO

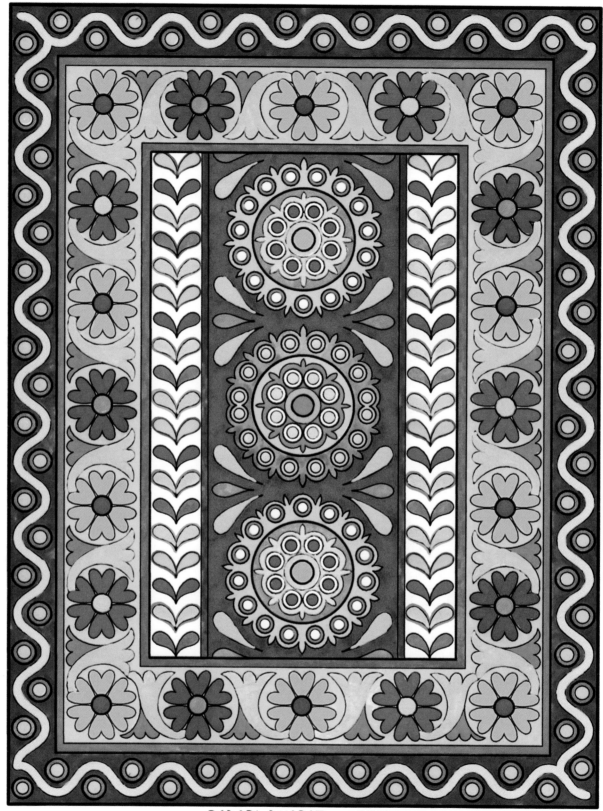

RABARI BHARAT — INDIA

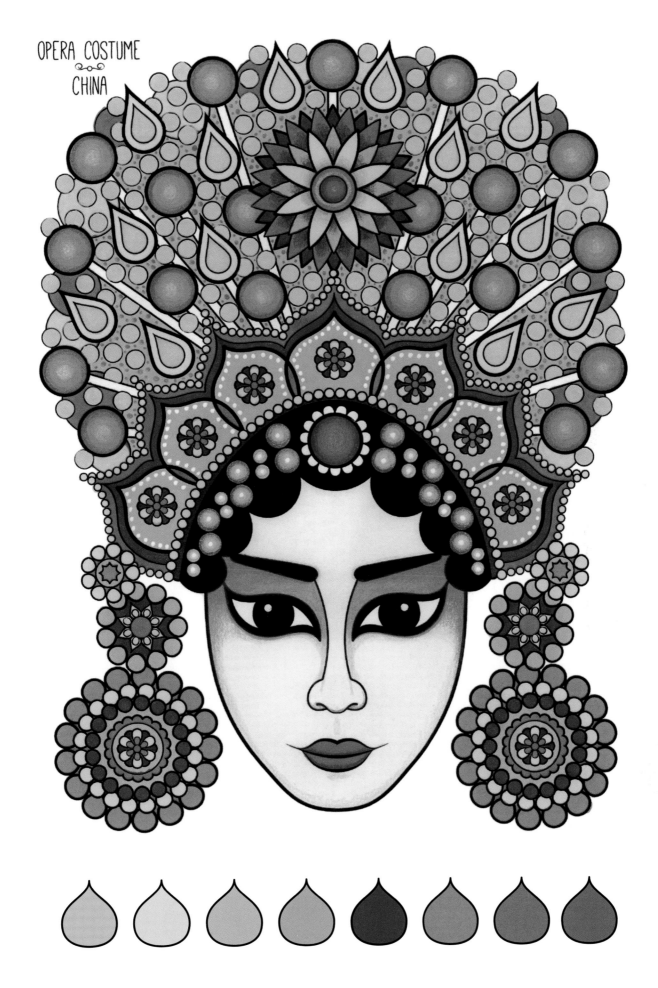

OPERA COSTUME
CHINA

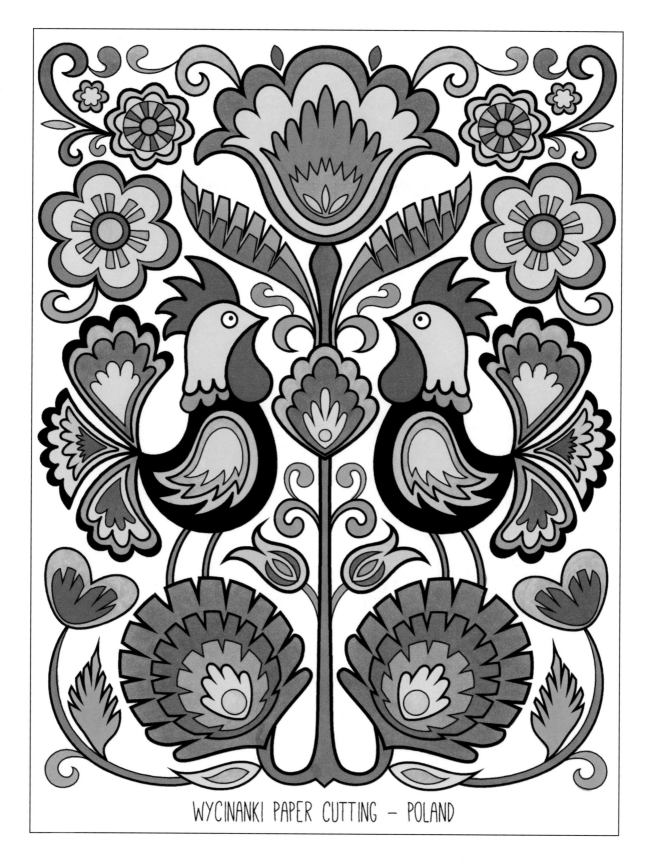

WYCINANKI PAPER CUTTING — POLAND

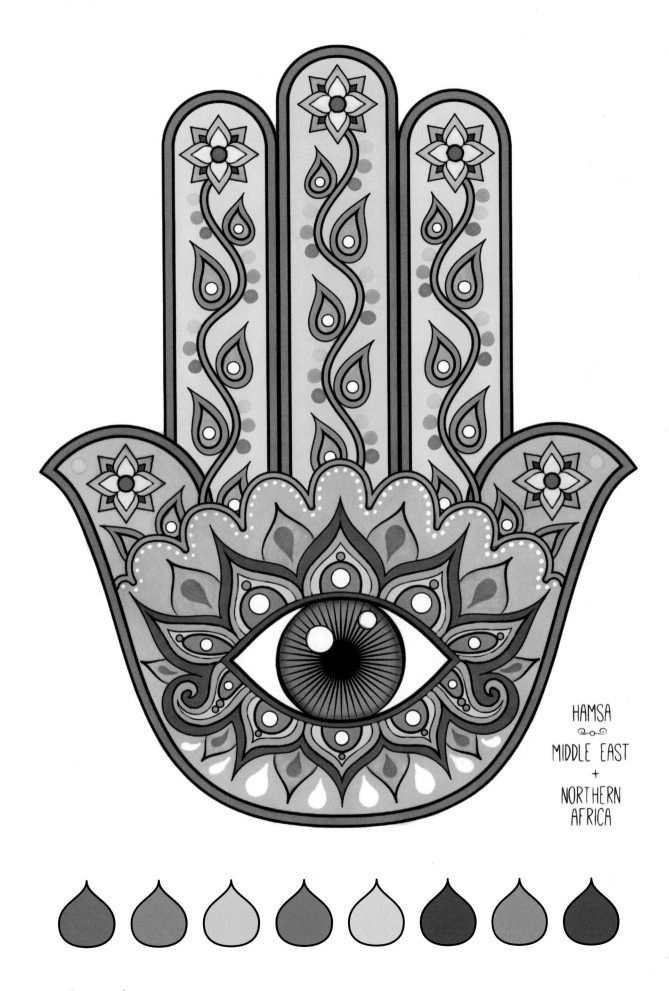

HAMSA

MIDDLE EAST
+
NORTHERN
AFRICA

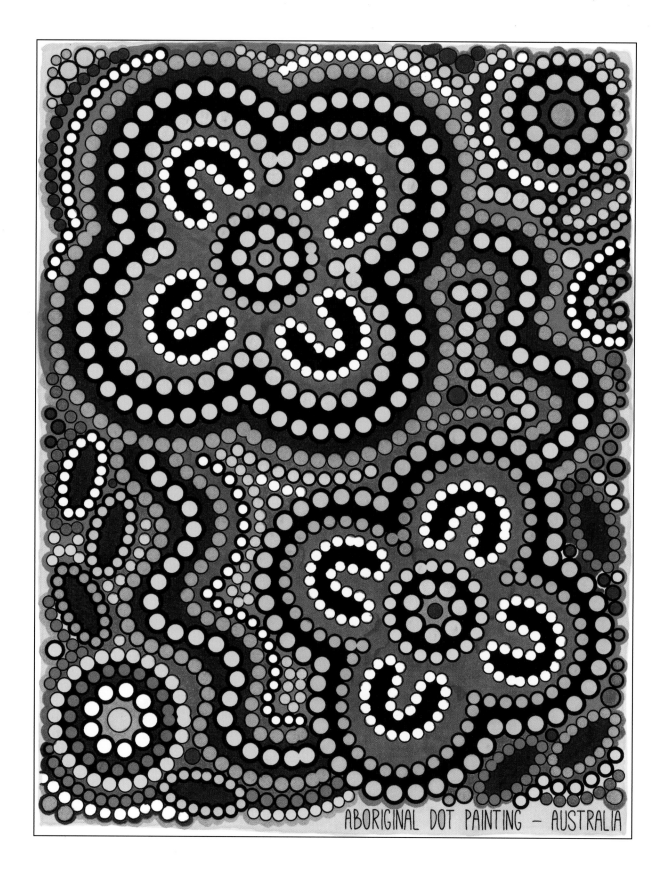

ABORIGINAL DOT PAINTING – AUSTRALIA

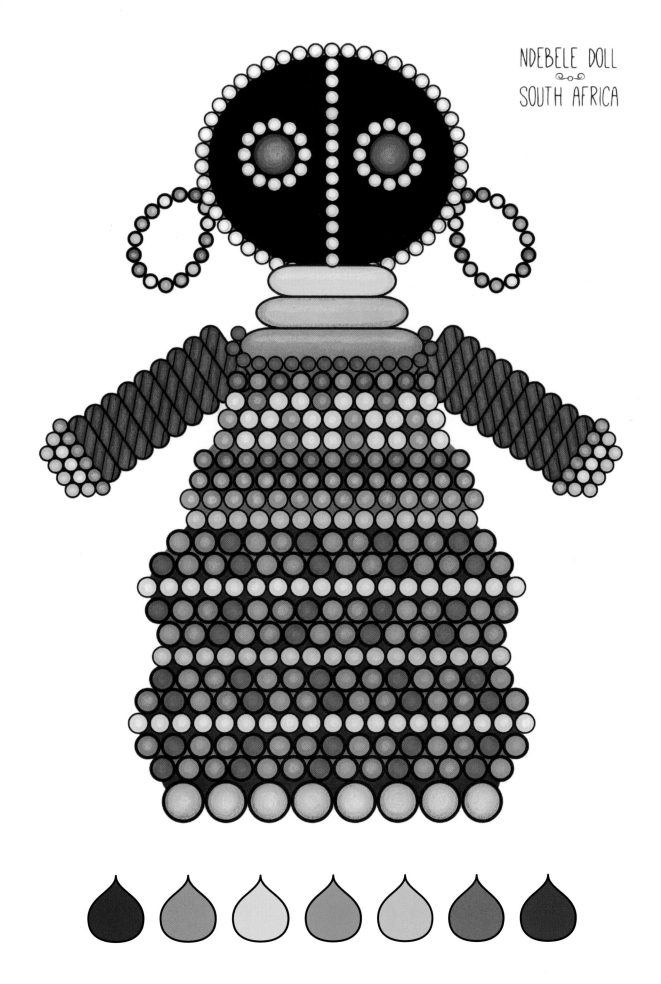

NDEBELE DOLL
SOUTH AFRICA

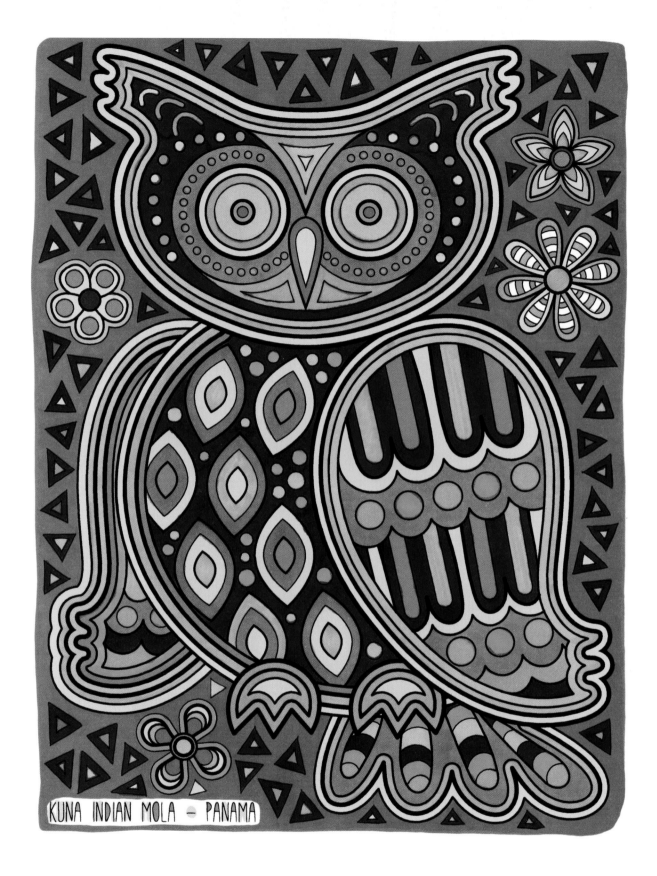

KUNA INDIAN MOLA - PANAMA

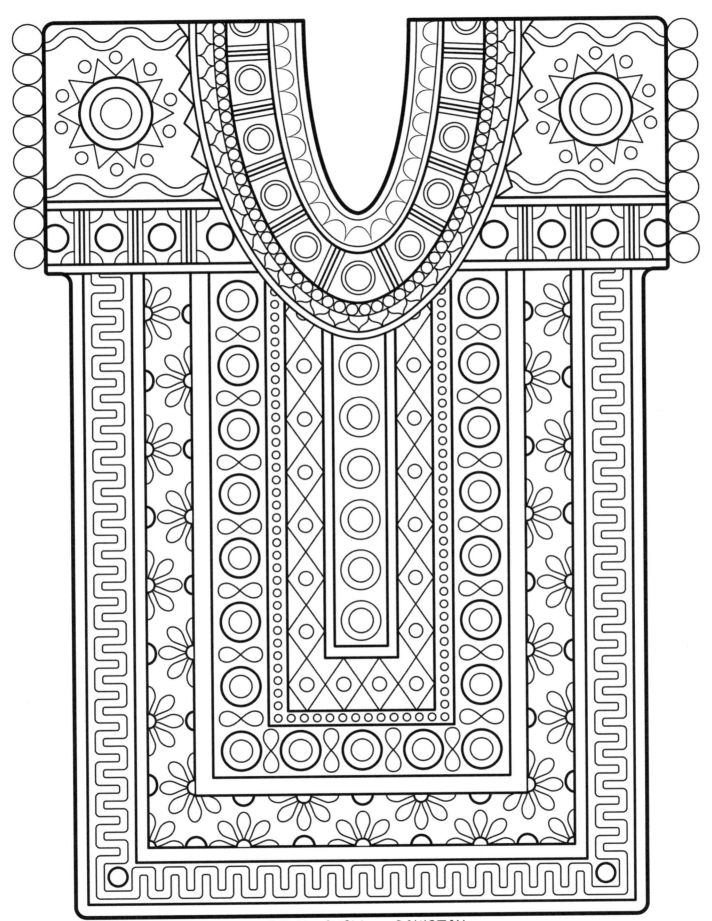

TRIBAL CHOLI - PAKISTAN

The moment you doubt whether you can fly, you cease forever to be able to do it.

—J. M. Barrie, *Peter Pan*

"Choli" refers to the intricate bodice of a beautifully adorned shift dress that, through the ages, paved the way for some of the most stunning Pakistani wedding dresses on the market.

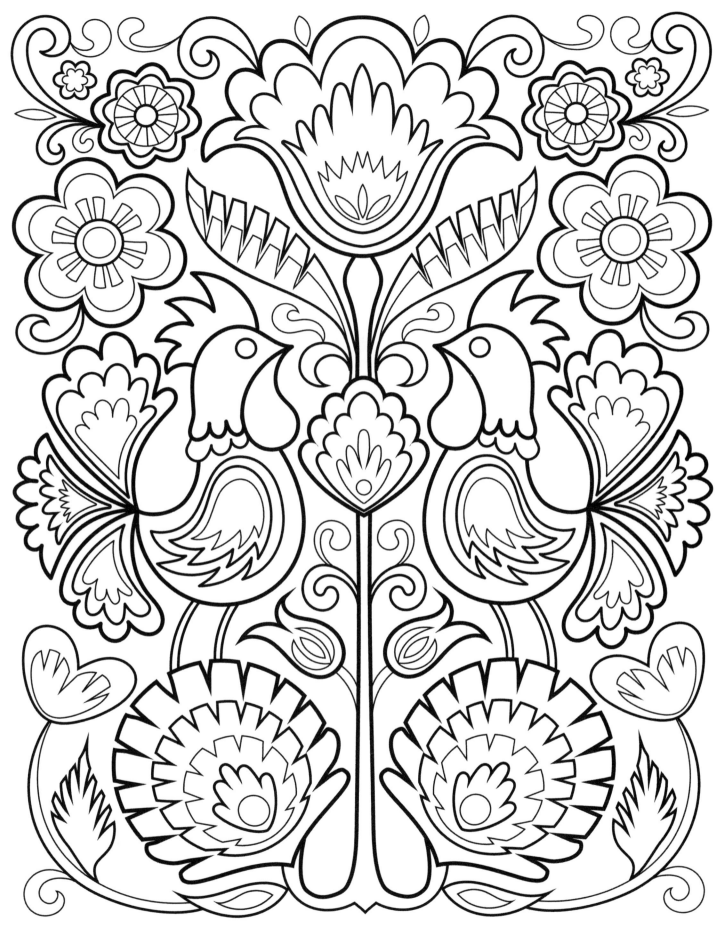

WYCINANKI PAPER CUTTING – POLAND

so much depends
upon

a red wheel
barrow

glazed with rain
water

beside the white
chickens.

—William Carlos Williams, *The Red Wheelbarrow*

Wycinanki is pronounced vee-chee-non-kee,
meaning "paper-cut design," and illustrates a perfectly
symmetrical array of beautiful color and shape.

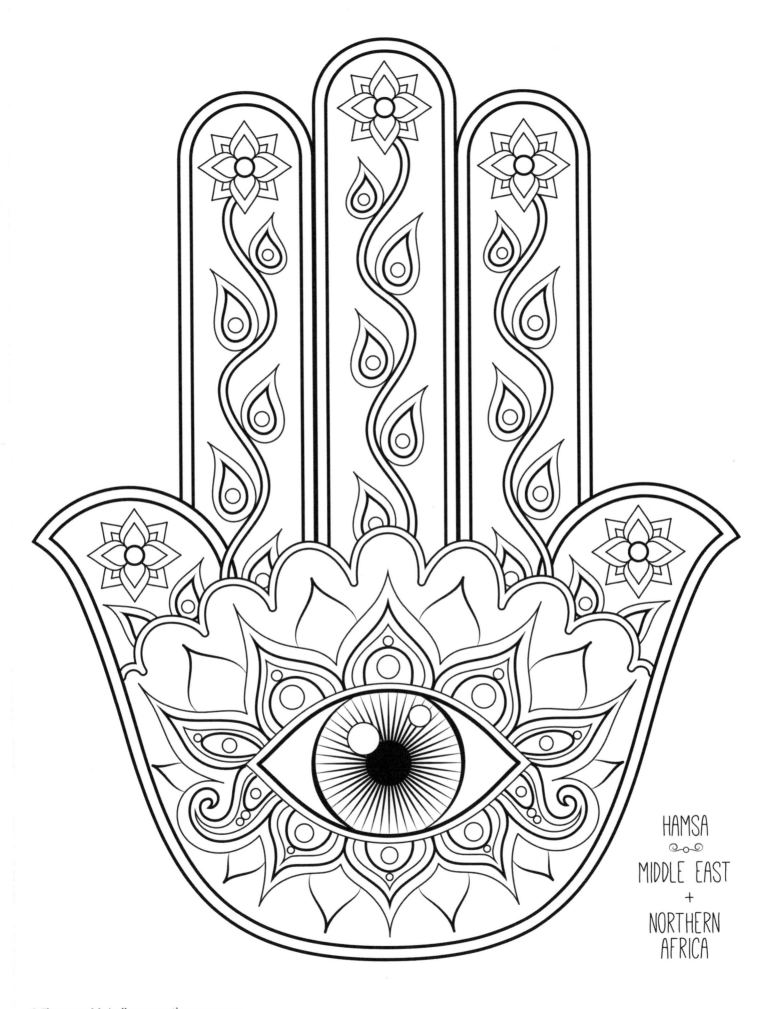

HAMSA
MIDDLE EAST
+
NORTHERN
AFRICA

Choose your thoughts carefully. Keep
what brings you peace, release what
brings you suffering, and know that
happiness is just a thought away.

—Nishan Panwar

The imagery of the eye in almost all hamsa designs acts
as a repellant to illness, death, and unluckiness.

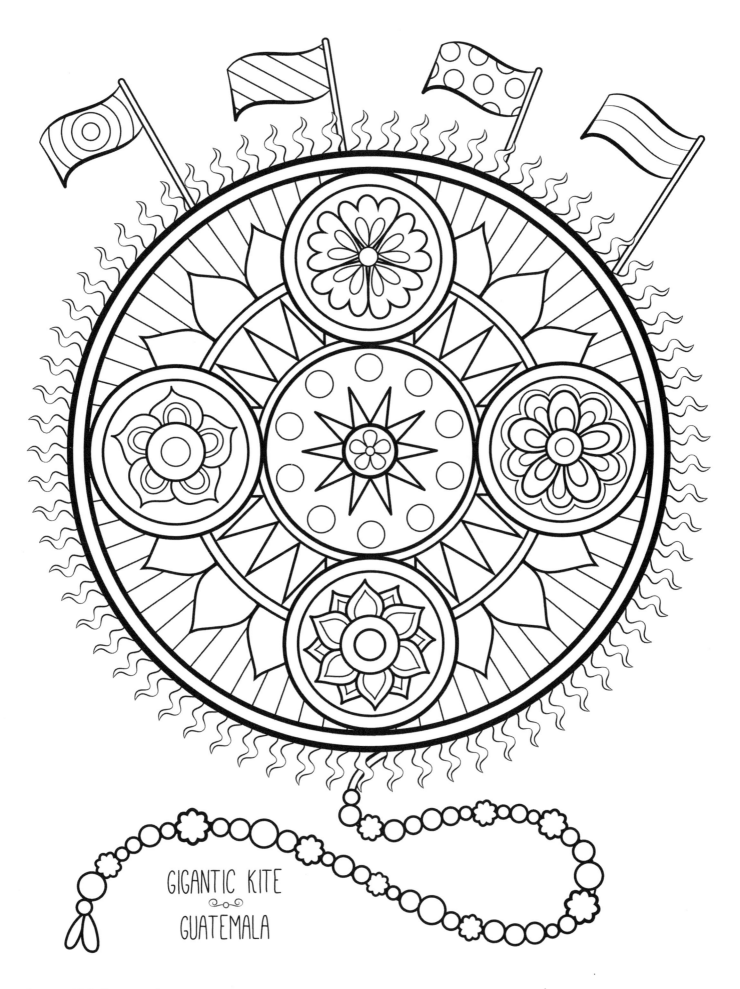

GIGANTIC KITE
GUATEMALA

True courage is like a kite; a contrary
wind raises it higher.

—Jean Petit-Senn

Each November, thousands of people travel to Sumpango,
Guatemala to view hundreds of tissue paper kites
created for the annual Day of the Dead Kite Festival.

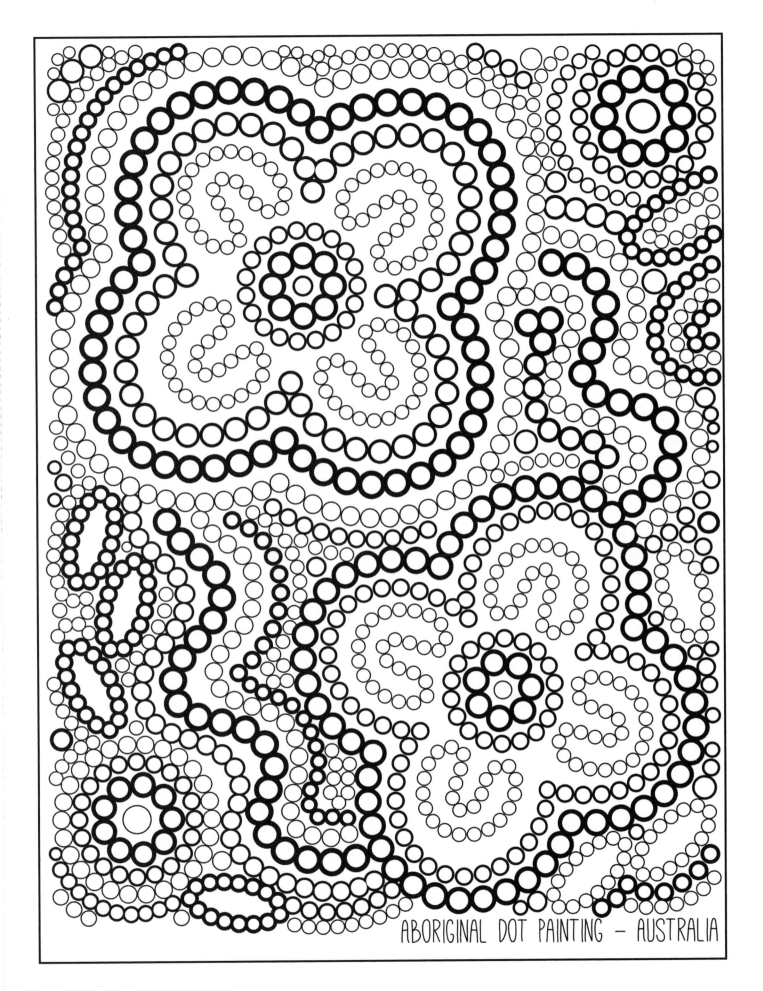

ABORIGINAL DOT PAINTING – AUSTRALIA

Traveler, there is no path.

The path is made by walking.

—Antonio Machado

Most Australian dot paintings can be found executed on boulders
and cave faces in the outback. The sun, soil, desert sand, clouds,
and sky are symbolized in the colors used in these creations.

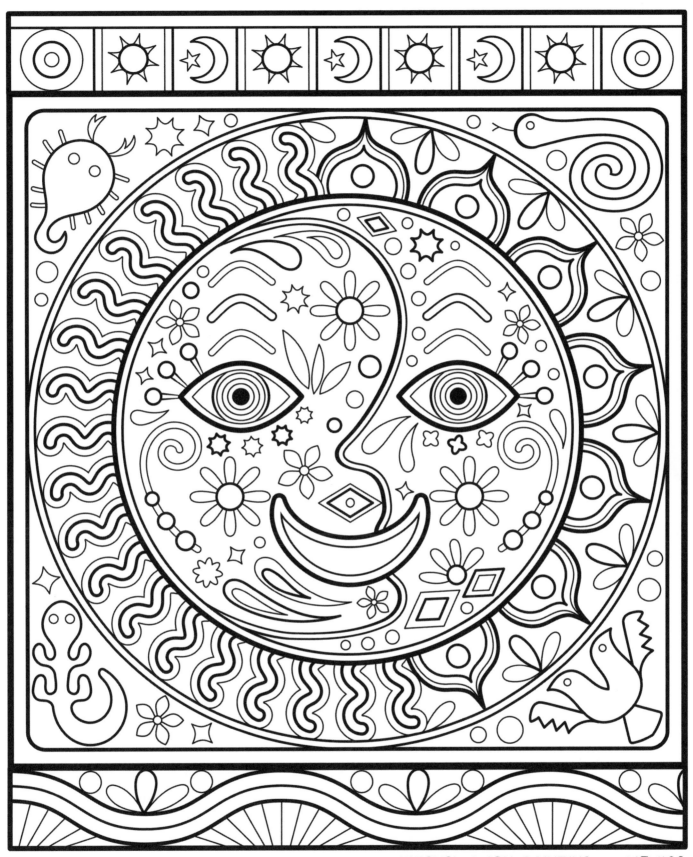

HUICHOL YARN PAINTING – MEXICO

Turn your face to the sun and the
shadows will fall behind you.

—Maori proverb

Bead and yarn paintings are referred to as *nierikas* and
are symbolic representations and offerings to the gods.

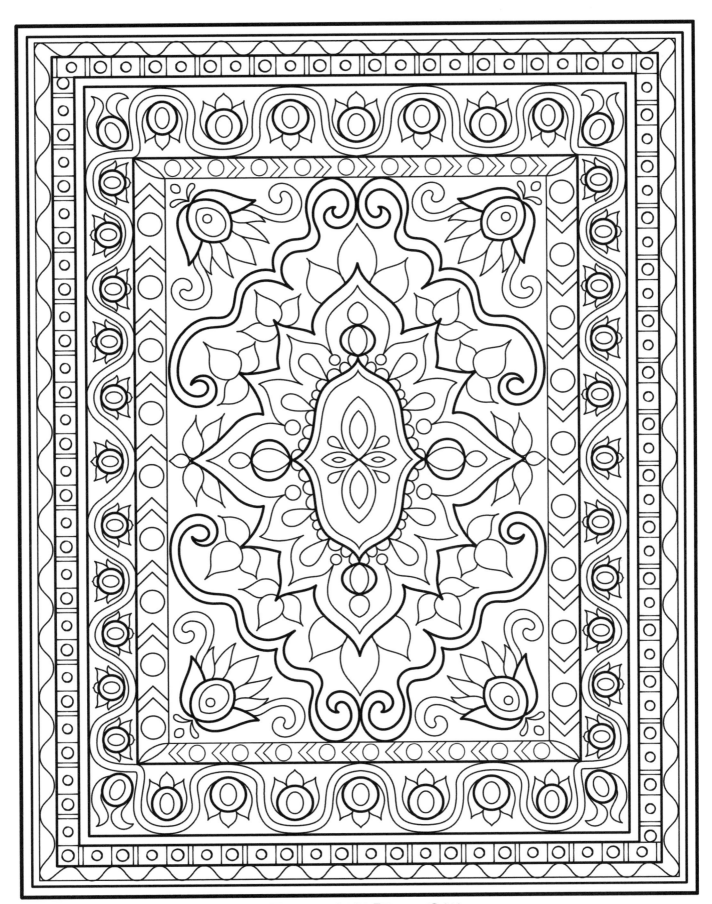

PERSIAN CARPET – IRAN

It's your road, and yours alone. Others may walk it with you, but no one can walk it for you.

—Unknown

The oldest known Persian rug is 2,500 years old and was found at the top of a mountain in Siberia.

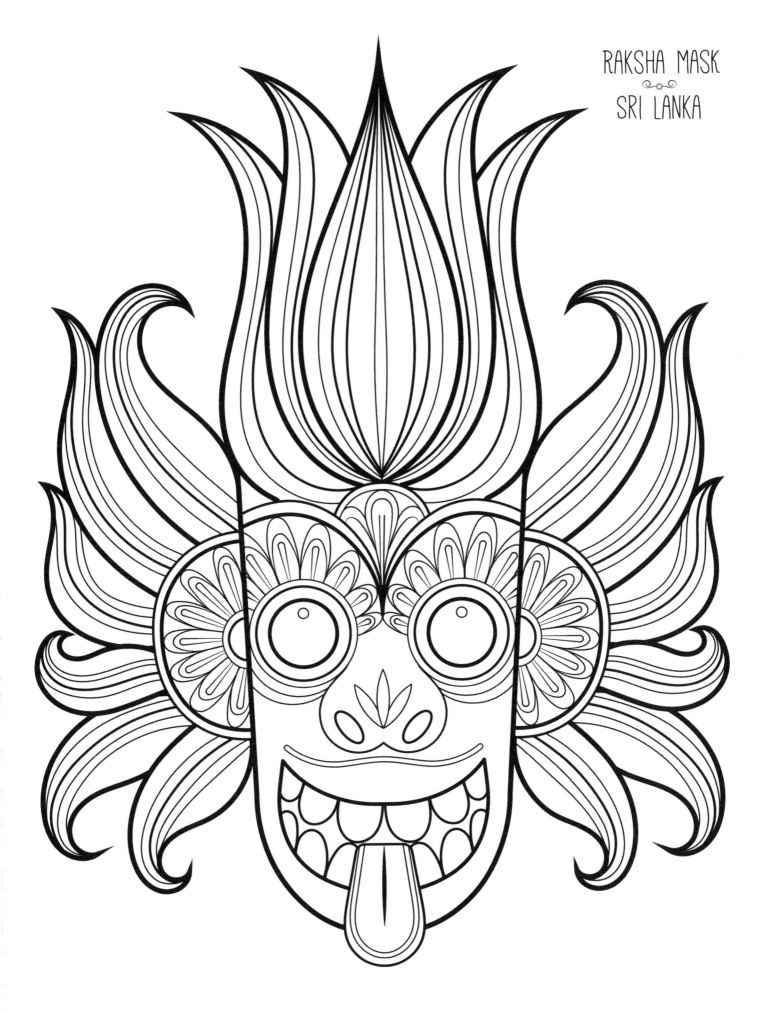

RAKSHA MASK
SRI LANKA

I'm not beautiful like you

I'm beautiful like me

—Joydrop, *Beautiful*

Raksha masks are ritual masks used to rid a person
or place of evil spirits and to cure ailments.

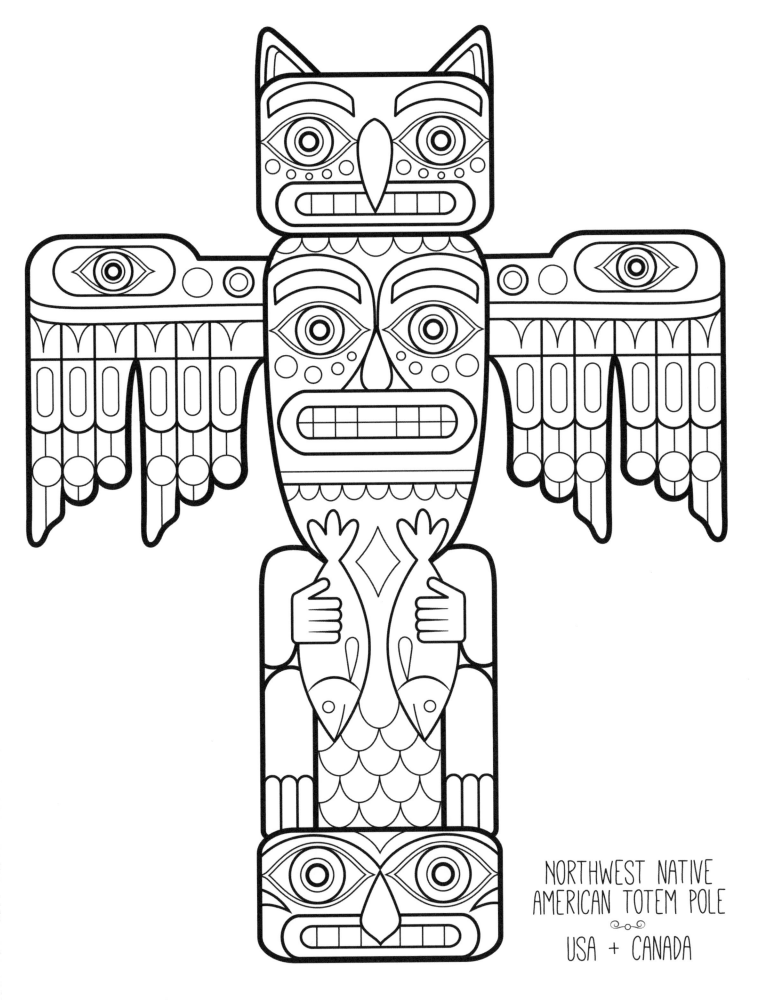

NORTHWEST NATIVE
AMERICAN TOTEM POLE
USA + CANADA

Be strong when you are weak. Be brave when you
are scared. Be humble when you are victorious.

—Unknown

Animals depicted on Native American totem poles have special
significance to each tribe's culture and lore, representing a wide
variety of honorable traits, such as loyalty and wisdom.

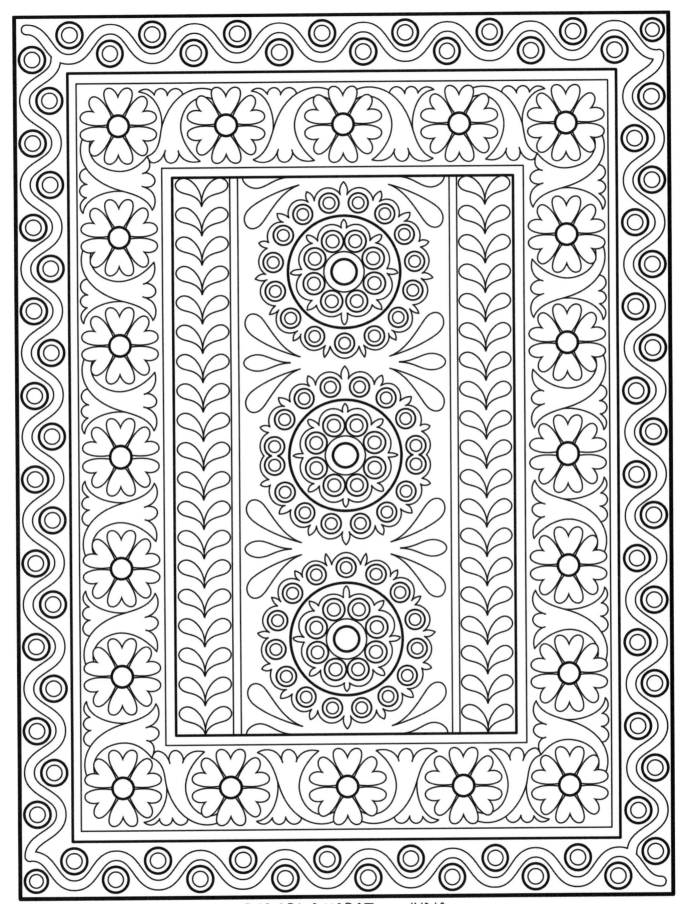

RABARI BHARAT – INDIA

Where there is love there is life.

—Mahatma Gandhi

In all Rabari villages, afternoons are the time for
embroidery, and the creations of the village women
artistically tell of the tribe's personal identity.

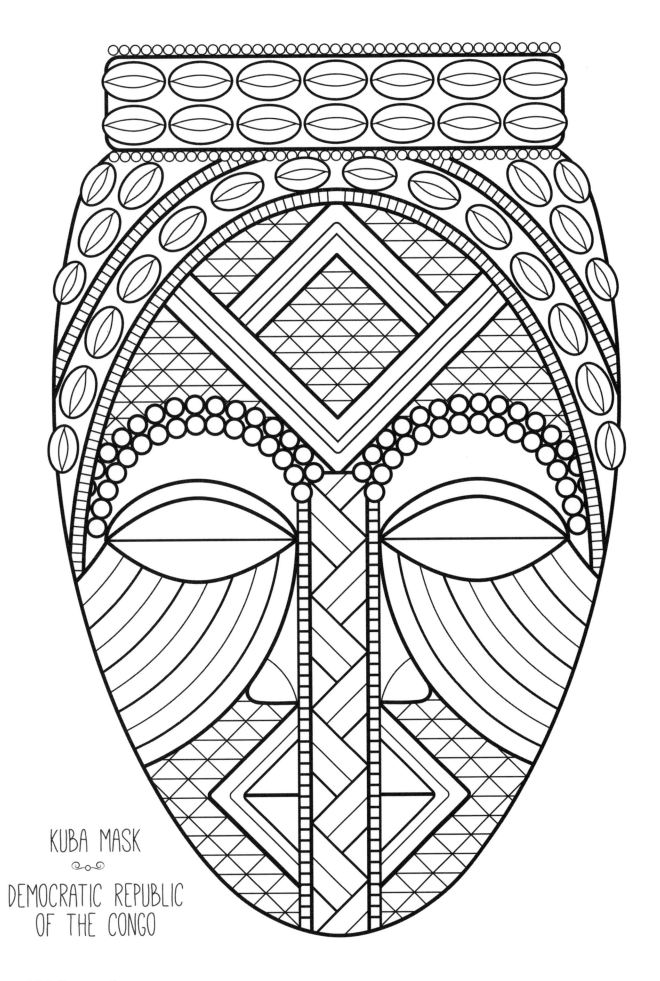

KUBA MASK

DEMOCRATIC REPUBLIC
OF THE CONGO

The mind of man is capable of anything.

—Joseph Conrad, *Heart of Darkness*

The Kuba mask was worn during the founding
of the Kuba kingdom, as well as during the
initiation ceremonies of the ruling family.

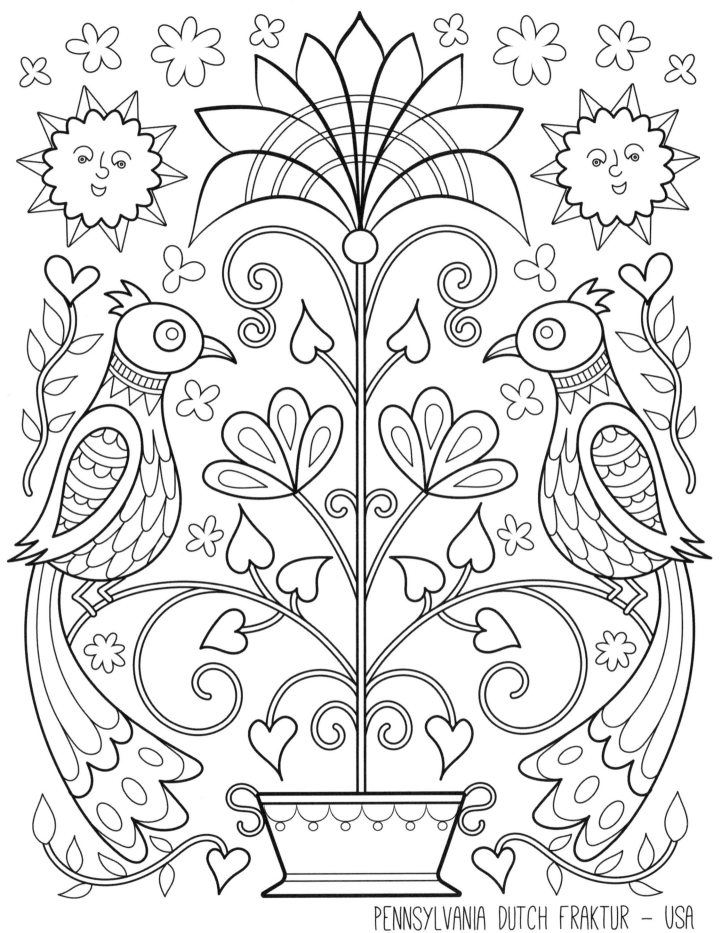

PENNSYLVANIA DUTCH FRAKTUR – USA

Faith is the bird that feels the light and
sings when the dawn is still dark.

—Rabindranath Tagore

Pennsylvania Dutch folk art, often featuring birds,
hearts, and tulips, is a popular decoration for writing
samples, birth and baptismal certificates, and house
blessings. Many barns around Pennsylvania have
frakturs hanging from their exterior entrances.

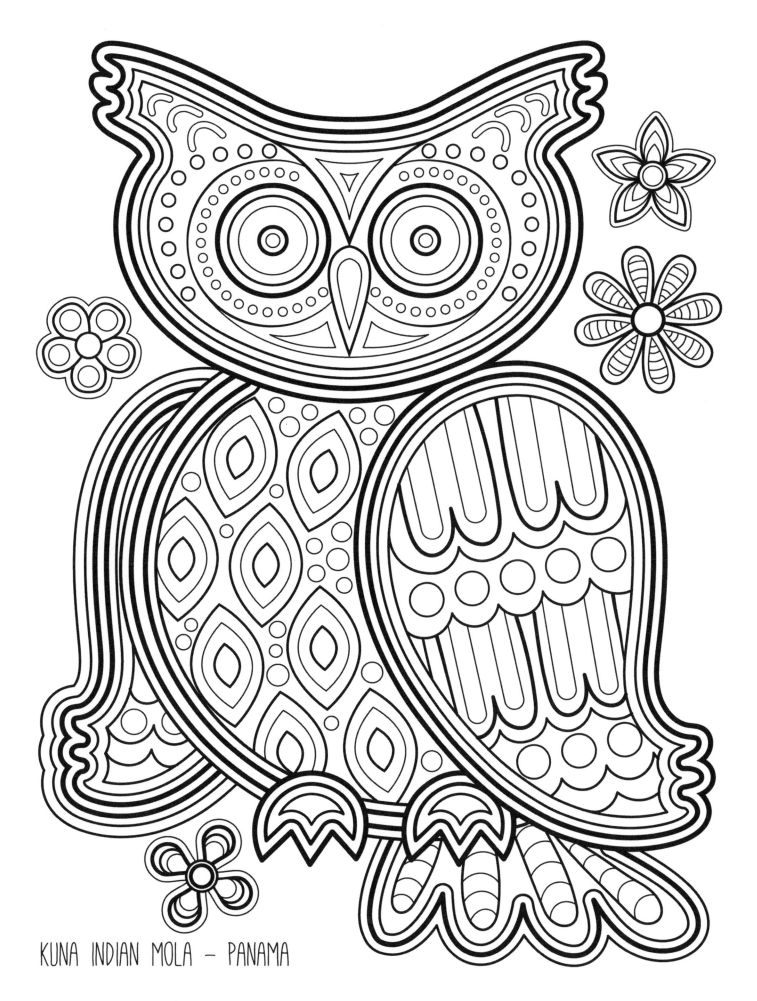

KUNA INDIAN MOLA – PANAMA

Knowing yourself is the beginning of all wisdom.

—Aristotle

Before the introduction of cloth fabrics to their culture, the
Kuna people would paint intricate, patterned designs onto
their bodies as a decorative element of their wardrobe.

AZULEJOS – PORTUGAL

Love the world and yourself in it.

—Audrey Niffenegger, *The Time Traveler's Wife*

Meaning "polished stone," *azulejos* ceramic tiles are
not only decorative elements in a home, but
also assist in climate control.

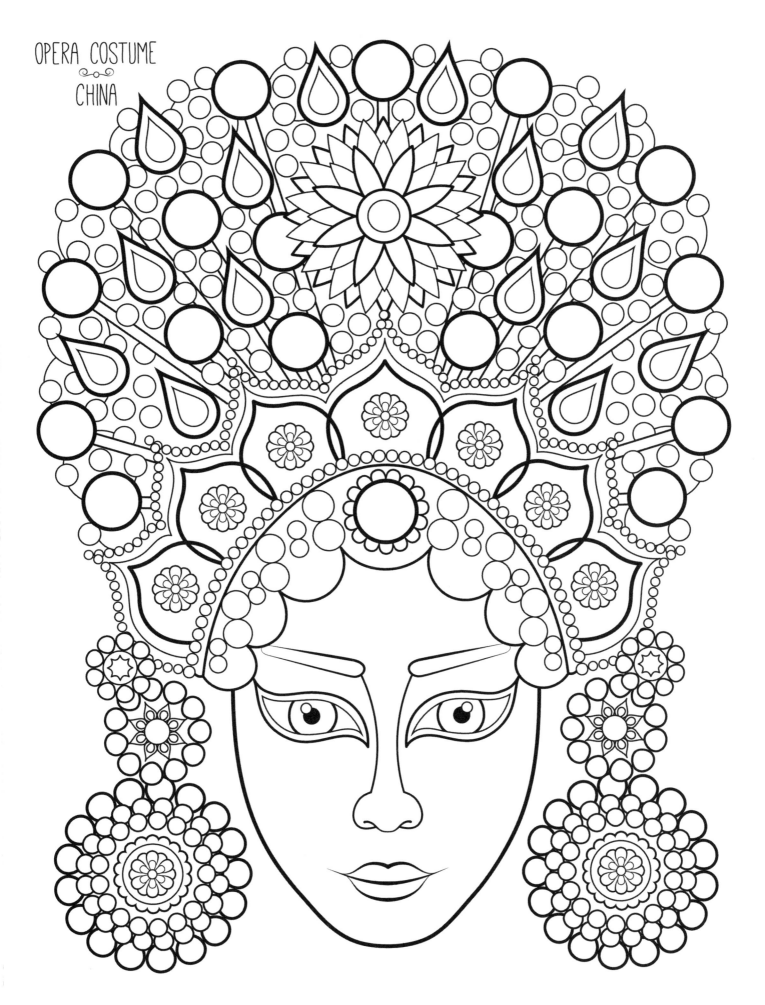

OPERA COSTUME
CHINA

A bird does not sing because it has an answer.
It sings because it has a song.

—Joan Walsh Anglund

Elaborate Chinese opera masks became popular
during the Northern Qi dynasty, when a dance called the
Big Face was created in honor of a mask-wearing
warrior named Gao Changgong.

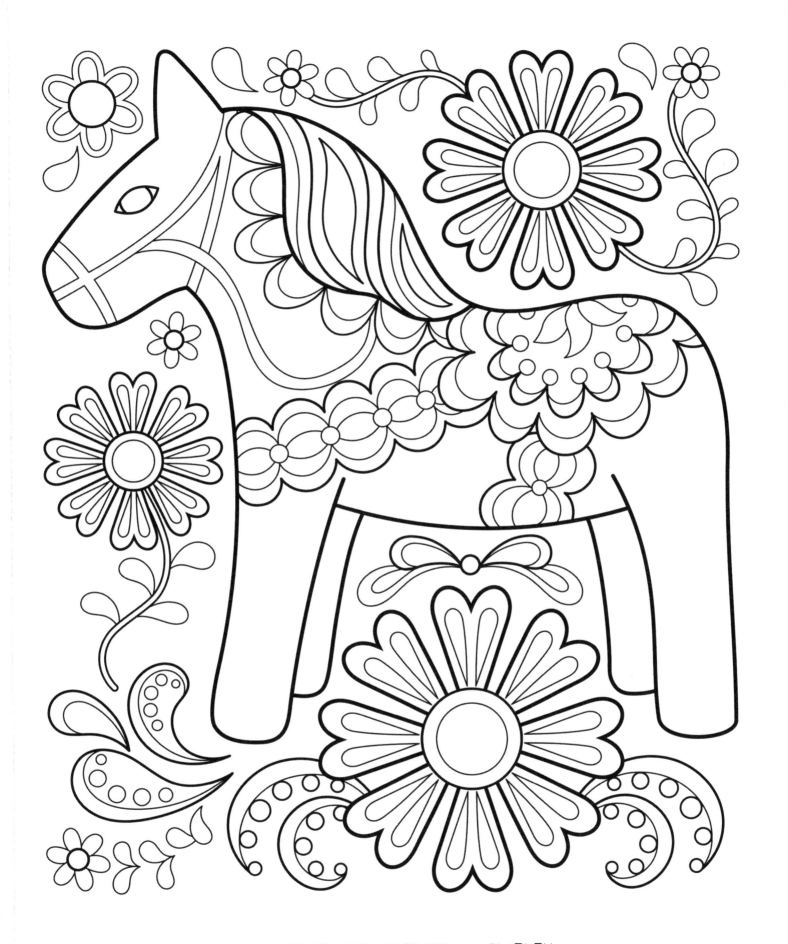

DALA HORSE AND KURBITS — SWEDEN

You're braver than you believe, stronger than you seem, and smarter than you think.

—A. A. Milne, *Winnie-the-Pooh*

The Dala horse is the national toy of Sweden and, according to legend, King Charles XII had them carved as gifts for guests.

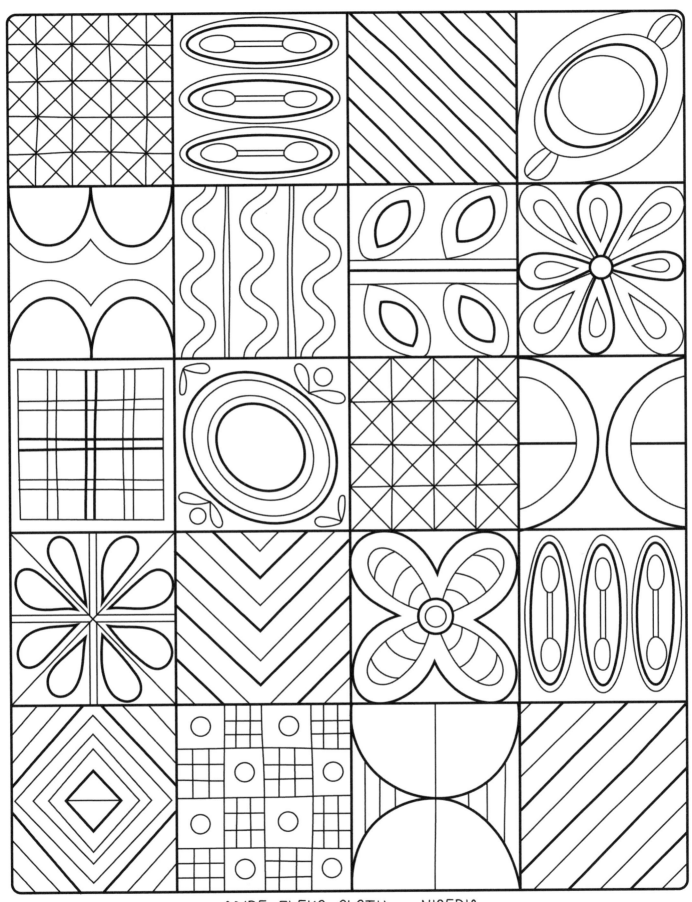

ADIRE ELEKO CLOTH — NIGERIA

If you are your authentic self,
you have no competition.

—Unknown

The designs made on the very first adire
cloths were drawn with a paste made
from starch and cassava root (the plant
used to make tapioca pudding!).

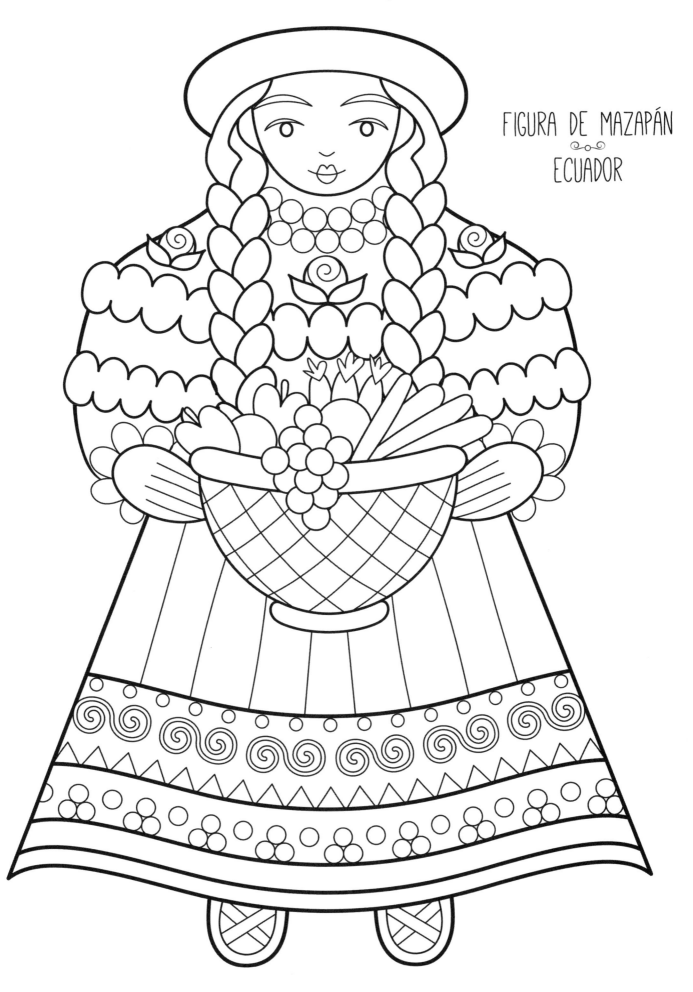

FIGURA DE MAZAPÁN
ECUADOR

Grow where you are planted.

—Unknown

"Marzipan figures," edible wheat flour and water figurines, began as a tribute during the Day of the Dead ceremony for those who had passed away.

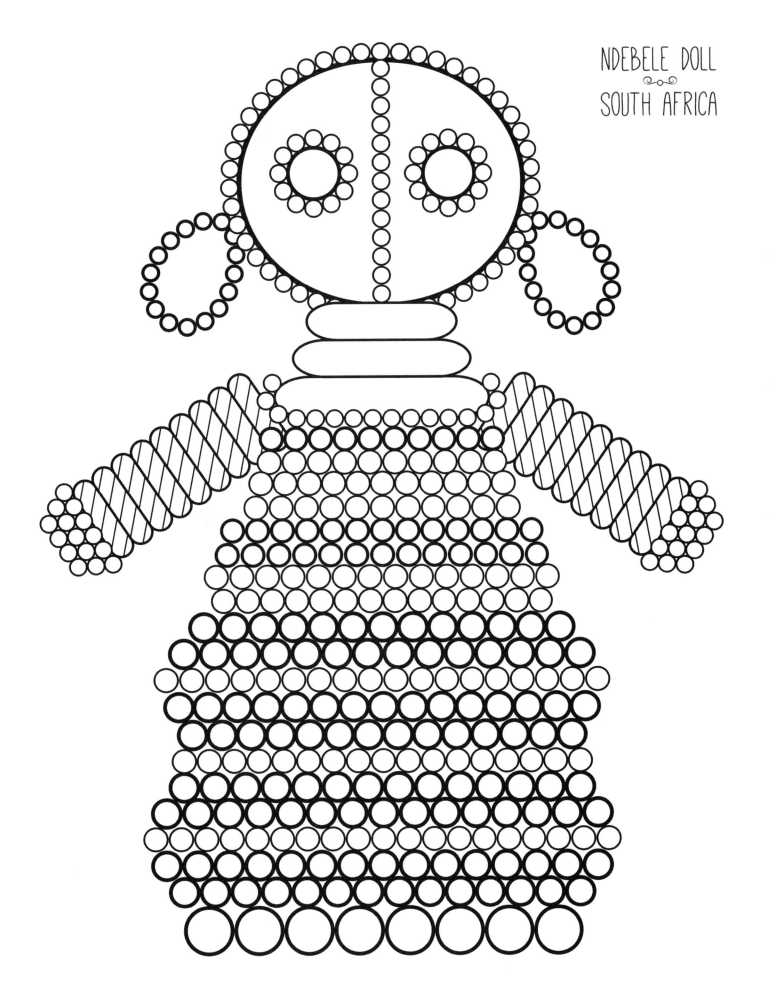

NDEBELE DOLL
SOUTH AFRICA

The girl with stars in her eyes will
shine like the moonlight.

—African proverb

When a young South African woman is preparing for
marriage, she receives a small, brightly colored doll to
name and care for. The name she chooses for her doll will
eventually become the name of her first child in marriage.

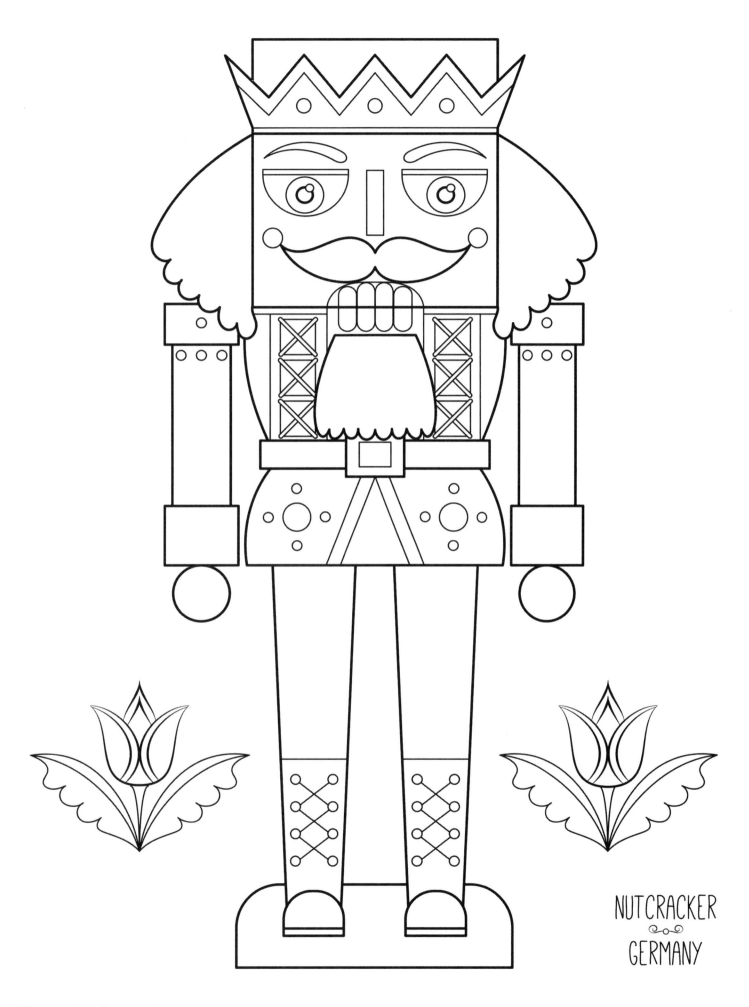

NUTCRACKER
GERMANY

Beware; for I am fearless,
and therefore powerful.

—Mary Shelley

Nutcrackers come to us from artisans of the Ore Mountains
in Germany, who carve the figures into many
different characters, such as coal miners,
soldiers, kings, and Santa Claus.

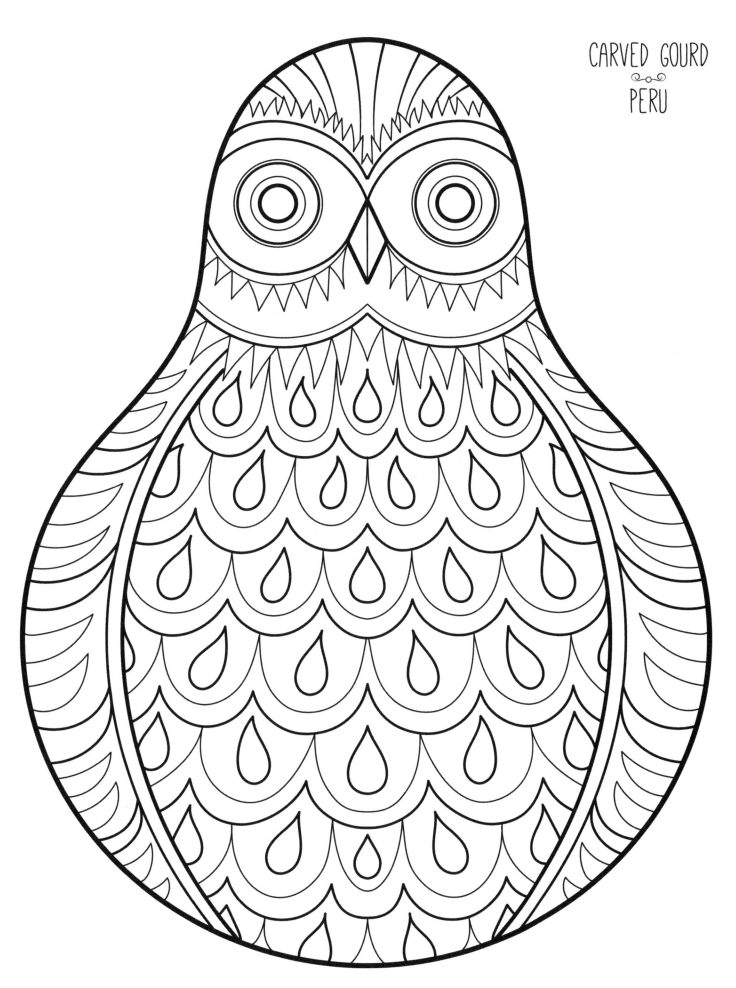

CARVED GOURD

PERU

The human race has only one really effective
weapon, and that is laughter.

—Mark Twain

Peruvian carved gourds serve as lovely and artistic home
accents, such as bowls and birdhouses, but one of the most
fun ways to use gourds is as a pair of maracas!

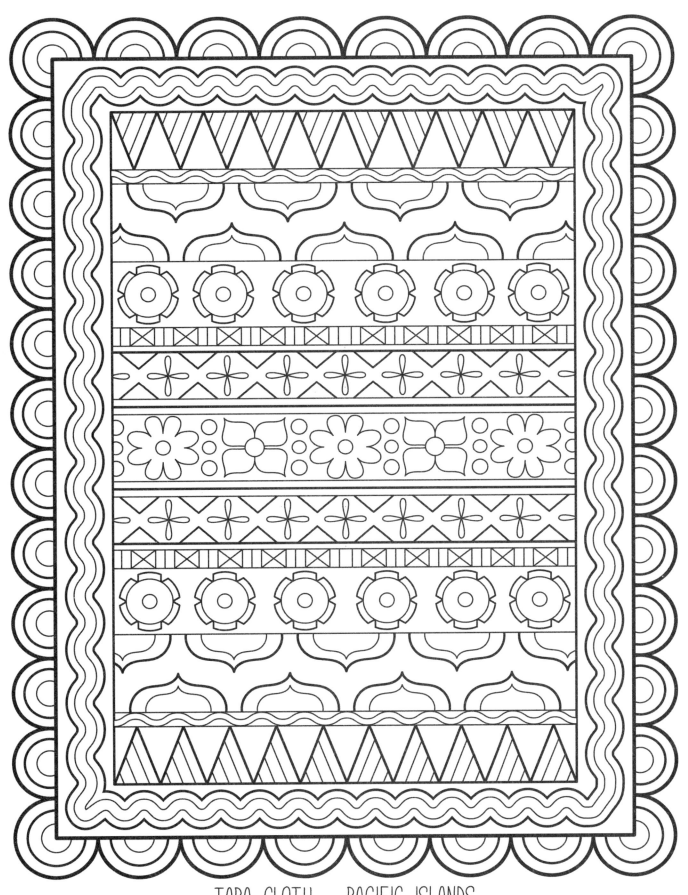

TAPA CLOTH – PACIFIC ISLANDS

A whole new world is waiting,

It's mine for the taking,

I know I can make it,

Today my life begins

—Bruno Mars, *Today My Life Begins*

Tapa cloth is a type of bark cloth most commonly made
from the inner fibers of indigenous trees. The cloth
is made by beating the fibers into flat sheets.

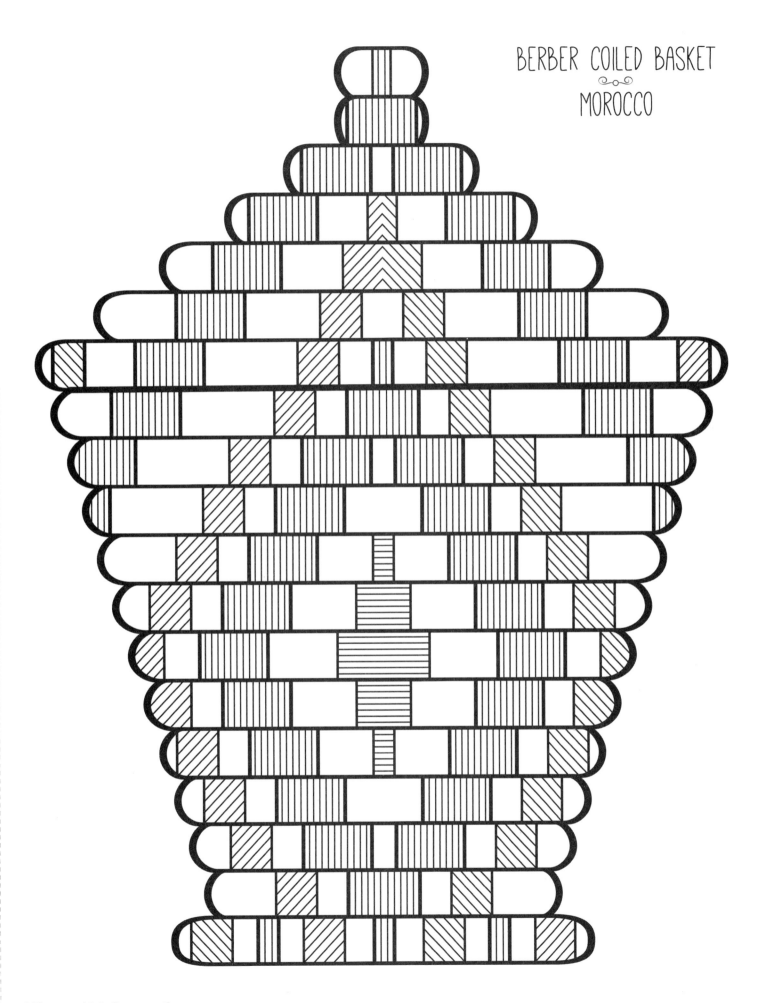

BERBER COILED BASKET

MOROCCO

We all have our own life to pursue, our own kind of dream to be weaving, and we all have the power to make wishes come true, as long as we keep believing.

—Louisa May Alcott

Be careful when exploring the streets of Morocco— snake charmers are known to carry deadly cobras and vipers inside their coiled baskets.

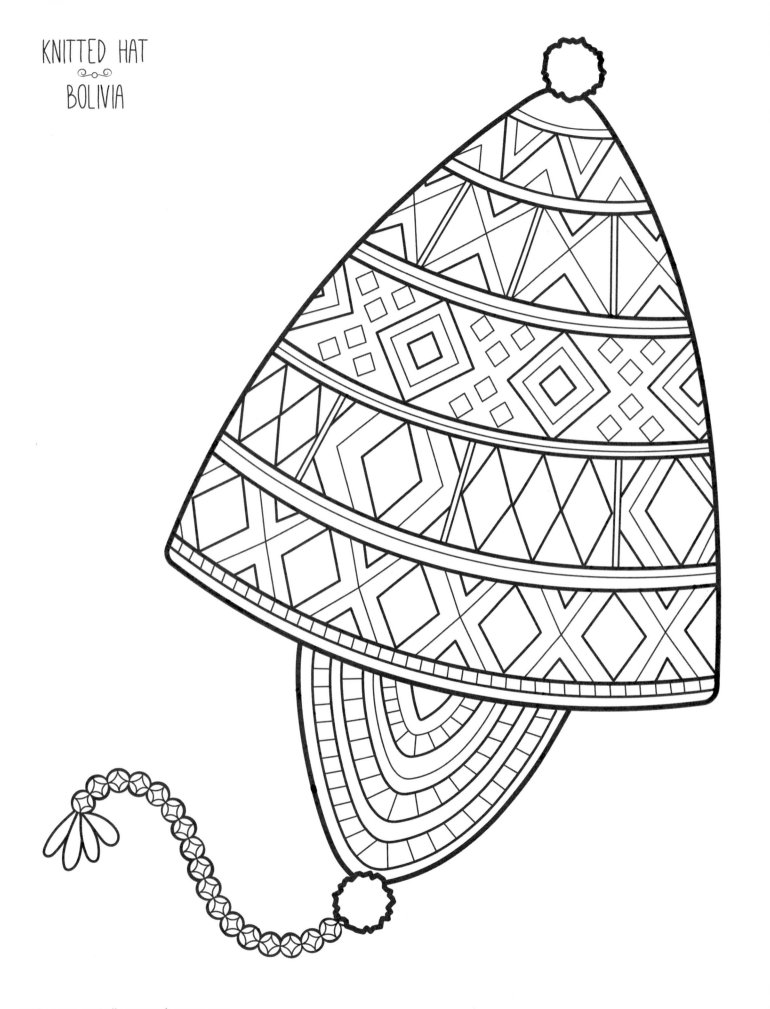

KNITTED HAT
BOLIVIA

Every mountaintop is within reach
if you just keep climbing.

—Unknown

Bolivian knitted hats, sweaters, scarves, and mittens
are primarily made from the wool of alpacas.

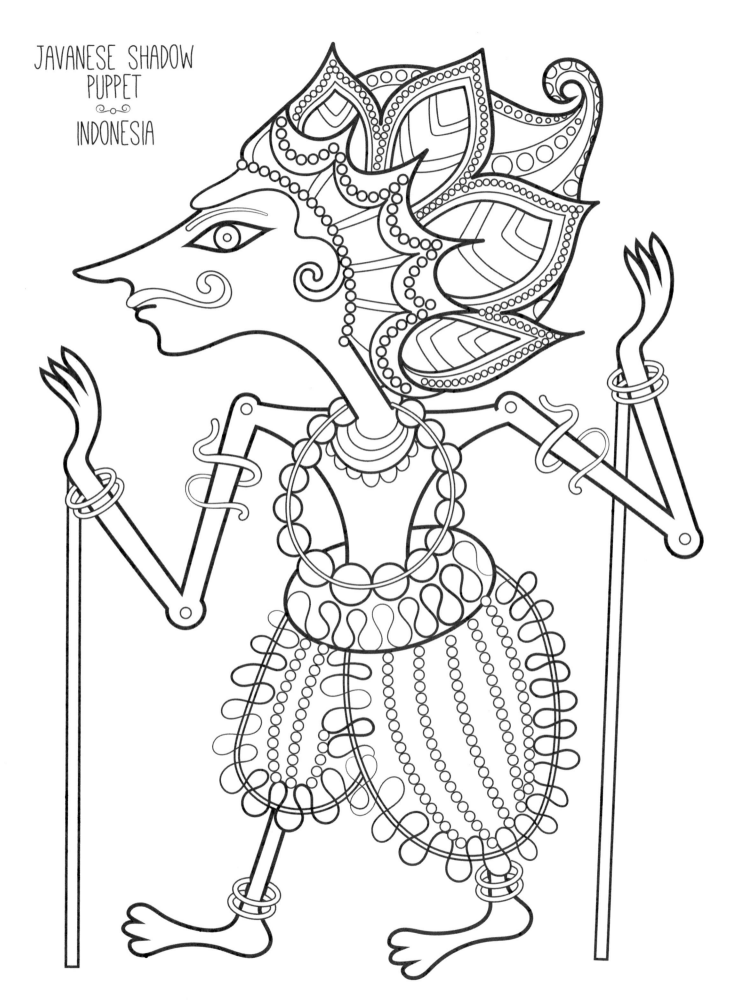

JAVANESE SHADOW
PUPPET
INDONESIA

Above the cloud with its shadow
is the star with its light.

—Pythagoras

Javanese shadow puppets are made from cured buffalo
hide and are mounted onto rods made of horn or bamboo.
They are the main characters in their own special
shows that present stories from the Hindu religion.

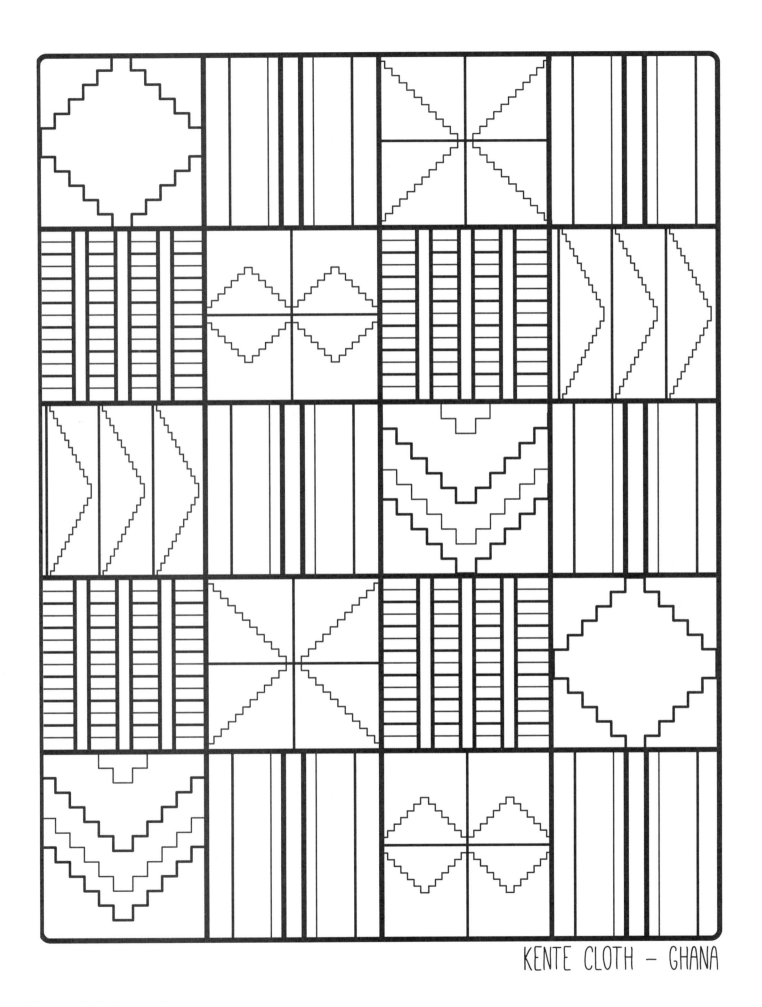

KENTE CLOTH – GHANA

Ah, yes, the past can hurt.
But the way I see it,
you can either run from it,
or learn from it.

Rafiki, *The Lion King*

In the language of Akan, kente cloth is known as *nwentom*
and is a sacred cloth worn only during moments of
extreme importance and by members of the upper class.

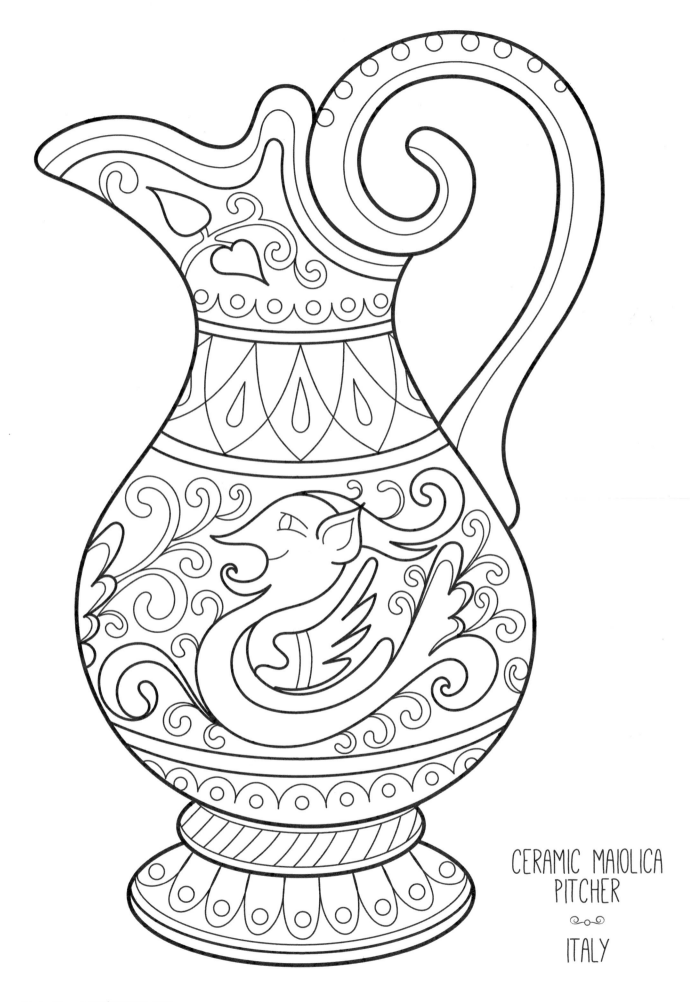

CERAMIC MAIOLICA
PITCHER

ITALY

Accept what life offers you and try to
drink from every cup.

Paulo Coelho, *Brida*

Maiolica is the name for tin-glazed pottery popular
during the Renaissance period that often displayed
historical events and legendary scenes.